Mallarmé's
FOR A TOMB OF ANATOLE

a personal translation

JACK HIRSCHMAN

Manic D Press
San Francisco

Cover painting by Jack Hirschman

ISBN 978-1-945665-13-4. For information, please address Manic D Press,
PO Box 410804, San Francisco, California 94141 www.manicdpress.com
Printed in Canada

A Poet's Grief
(An Introduction)

On March 2, 1982, David Hirschman died in Venice, California after three and a half years of struggle with an acute form of leukemic cancer. He was twenty -five years old, a photographer and student-worker. Now, a month later, his ashes part of the Big Tujunga Canyon of the Angeles National Forest he loved so well, I sit writing this introduction to a book I never shared with my deep young comrade and son, though I translated it twelve years ago when I still lived with him and his mother, Ruth, and his sister, Celia.

The contents of this book were scrawled on un-numbered pages by the noted French master, Stéphane Mallarmé, in 1879, noting the illness and then the death of his small son of eight years, Anatole, via complications come from scarlet fever. When I translated the leaves in that little house on Quarterdeck St., on the Marina edge of Venice, David was thirteen years old. The manuscript of the translation that I made with the kind help of Stephen Marcus, who visited the house and helped me with important clarifications, was kept in hand-written form and taken with me to San Francisco when Ruth and I separated. For many years it has remained in the top drawer of my desk in North Beach. Though on two occasions I publicly read from some of the leaves, I have never published this text until now.

In many respects, because the contents of the book — even after David learned of his cancer in 1978 — were unthinkable to me, because the death of one's son is considered the most insurmountable tragedy that can befall a

parent, and because my writings and translations in recent years, as a communist, have been concerned — so far as death is the issue — with a sense of rage at all the lethal paths of capitalism, this book is my most "personal" translation. I don't mean by this that this text is a capitalism I kept hidden in my drawer, because what Mallarmé attempts to construct through his confrontation with death and grief is actually an eternalized continuance that is very familiar to communists. Moreover, I can also envision the day when David will be written into my work as a victim of cancerous radiation or other forms of the poisonous inflations that are robbing so many young people of their lives.

And I do not mean by "personal" a sense of guilt at having stumbled upon a text of a great poet who had already influenced my own work, and, translating it, realized its content was tragic, and perhaps even contagious. We may be said to live and die for poetry, and some have even killed or been killed for poetry, but neither David (had he read the text) nor I could ever believe that what Mallarmé writes herein could be the cause of anyone's death. No, the reason I hold this book to be so very personal to me is because, in the years when I was no longer a father *en famille*, though David and I saw one another in each other's growth, on his visits as a student to San Francisco, or on mine to Los Angeles, it was through Mallarmé's text, in that space of *as-if* which inscribes both the death of his son and is the condition of feeling on the part of every child and adult involved in separation and/or divorce (*as-if* meaning as if the father were dead or the son were dead) that we made space brotherly and filled it with so much of the movement of the music that is life.

At the root of his musical inspirativeness (it was he, through brotherly and sisterly transfers, who inspired the inventiveness of my long jazz poem "Schnaap's Son," a work which remains the most completely texted jazz poem in American writing—thanks to David's contraction—) and at the core of his international sensibility (it was his study of the Russian language which "led" me one day to try translating Russian on the streets of San Francisco) there was a strong comrade who had assimilated many of the avant-garde attitudes I and fellow artists had infused our children with in the Sixties; was cool, implacable and unsentimental about death; knew with wry affection why the guys known as The Grateful Dead chose that name; and bravely lived his life, among sexual angels and musical and imagistic artifacts, inquisitive about the deepest of all penetrations.

4

Death *is* that penetration, that entrance into the self-as-other by way of the physical extinction of the body. The track of such an entrance is lined with loss and grief for the survivors; and within this grief there is often an unspeakable abundance of awareness of the leveling and equalizing power of death. In the case of Anatole Mallarmé, too young to be conscious that death is what we are born with and what we gather toward, and so small as to still be part of what is so very innocent in potentiality, the grief of his father is expressed in a series of sobbed notations more emotionally surfaced than any other piece of writing by that otherwise succinct diamond-cutter of language. Within the written confrontation, however, Mallarmé already is projecting a three-part structure based upon his almost immediate attempt — born no doubt from the believing disbelief of his son's death — to go forward with the dead child eternalized to his essence in the poet.

The French editor of the original text implies that such a process of eternalization can only be achieved by a literary act, but I believe Jean-Pierre Richard is mistaken in this. Mallarmé, after all, is noting a universal process: even one who doesn't write, upon experiencing the loss of someone dear, will struggle within the immersion into sorrow for an image of a loved one. Indeed, religious resurrection is founded upon such an idea: Death happens, Nothingness is made physical along the plane of transiency, and yet the human spirit continues the relation, now physically informed by the non-physical and utterly inward. The difference with Mallarmé, or other poets (poetry being forever at the service of the processes of life and death), is that his notations already begin as harmonic affirmations for the whole of the world, not simply in attainment of the image of a dead child. When Mallarmé writes:

<div align="center">

son

reabsorbed

not gone

it's him

or his brother

me —

I've told

him it—

two brothers

</div>

he is already beginning to hear and be taught by the immense penetration

and process of death; and the repetitions of sobs, blurts, rapid scrawls, as if physical and non-physical voices were interpenetrating, indicate his willingness to completely transform his identity with that of the child. Moreover, there are leaves where both the child's mother and sister figure as personages in an inner family drama, extending or objectifying the grief of the father and the life of the son who has entered all of them as

> paragon
> we've known
> through you this 'something
> better than ourselves'
> often eludes
> us — yet will be
> in us — our
> acts — now

> child, idealized
> sperm

Mallarmé left his book of notations in notebook form and they were published in 1961. To my knowledge, *For A Tomb of Anatole* is not considered in the 'literary' canon of Mallarmé's though anyone reading this book cannot fail to be gripped by the sincerity of the spontaneous responses to his tragedy. Even where he is projecting structure, the profound emotional content is both brave and consoling, and the intellective content, given the tragedy itself, never wanes. Sorrow, doubt, despair, recovery, purification — these are what the poet engages in a series of responses which, happily, now can be part of general sensibility. Personally, he has written the immediate confrontation with sickness unto death, and through the death itself as well as any human being could be expected to, and for that reason I know that my own son's mother and sister, as well as any who have lived the physical dying of a loved one, will recognize their own courage reading this book.

My father's name is Stephen, the same as the poet's, and during the years of separation and divorce, relations between grandfather and grandson were severed. In this respect, the text could be an expression of my deadness in being unable and unwilling to organically connect the threads of the generations. Yet I recall that after writing out the translation in the early Seventies, I

penned a brief introduction in which I mentioned a small boy, Jerome Wrubel by name, who was the son of the next-door neighbors in the little apartment house my parents, my sister and I occupied when I was myself a small boy in The Bronx. Jerome died of a child's disease at the age of nine, and he was re-evoked by the translation, as were the children of brother poet-artist George Herms and poet Robert Creeley, both of whom were taken at early ages, the former's by disease and the latter's by a fatal accident, during the Sixties.

In all these instances, the men have played an important part in my life: Stephen, who actually began my love of the *act* of writing and art-making; George, whose spontaneous creative abilities helped see me through the Vietnam War years; and Robert, who, perhaps more than any other American poet, has evoked in some of his works a Mallarméan world. In fact, in my own "The Portrait," which appeared in *Oboe* #5 and is the expression of the communism of the art of the human face as poetry, explicit references are made to both Robert's and Mallarmé's poetry because it has been the form that communism has taken with respect to the arts in recent years which has been one of my major concerns, i.e., the interplay between the word and visual arts in order to bring about a more grounded proletarian statement. And who knows but that even the father of Jerome Wrubel, David by name, has played a role in my work; for he was and is a book-poring religious man and it was in his presence that I first experienced, outside a synagogue, a man of Talmud and Kabbala.

What I mean to suggest is that the aura contingent upon the death of the young, like that of the suicided, leaves powerful trace upon humanity because the natural life-process and death-gathering is either intensely sped up through illness or accident, or abruptly shattered by an act of the will. The resultant abyss experienced by the living is one that is bound to evoke deep change, dramatic realignments of the sensibility.

With Mallarmé we are confronted by a poet who aesthetically and philosophically reflects the awareness of Nothingness come over Europe via the rising tide of capital, the breakdown of the old order, romantic apotheosis, the escape into drugs, communist manifestations and an intuition of the coming of age of the proletariat. His poetry becomes, in its literateness, its writtenness, a vessel for the rarified essences of deposed crowns, or at least the jewels on such crowns. This Nothingness, with a capital N, is the name of

the desperate refuge of attitude and style for those recoiling from the onset of the common man, and in this he may be correctly said to reflect a deep conservative position. But while he shuddered at the thought of the usury on the horizon and wrote in an idiom both mystifying and 'uncommon' more than any other poet of the last century, Mallarmé was in advance of his time. With his poem, "A Throw of the Dice," he foresaw the cinematic musicalization of the page; and his notations for "The Book," a vast mathematical panorama of mass-theater hypotheses, belong more to the age of computers than to traditionally written poetry or discourse. With "For a Tomb of Anatole," still another breakthrough is evident.

Here, Mallarmé is abruptly confronted by the nothingness of physical extinction, the nothingness with a small n (to indicate Mallarmé's own distinction). And what do we perceive? All defenses against the blood-rush of reality collapse. His notations are as if uttered or spoken in the 'ordinary' light of the mind, that is, closer to the inner conversational stream of 20th century consciousness. Where there is obscurity it is because the poet is attempting structurally to project a terminal form for the grief he feels, or because, in the uprush of his emotions the interpenetrating pronouns of the family drama, in which Death has come to play a part, are slurred into one another.

Though he was to leave his responses to his son's death in this form as an extended 'jotting' and return to his literary style during the last fifteen years of his life, Mallarmé has written himself into contemporary 20th century voice with this book, and in such a way as to give comfort and meaning to all those who experience the dark passage of grief at the loss of one close to the heart.

<div align="right">

Jack Hirschman
San Francisco
April 1982

</div>

8

Mallarmé's

FOR A TOMB OF ANATOLE

child coming out of
us two holding
up to us our
ideal — the way
for us — father
and mother sur-
 viving him in
sad existence,
two extremes,
sore members in him
who are divided —
out of which his death
Nul of this little childself

better
than if
he still were —
 whatever they were, i.e.,
a few noble
qualities,
etc.,
the hours when
you were there and were
not

ill in
spring
dead in autumn
it's the sun —

the wave
idea coughing

son
reabsorbed
Not gone
it's him
or his brother
me —
I've told
him it —
Two brothers

taken back to be left
along the flank—
 sure of me
 the century
 will not flow out,
just right for

 teaching me

I didn't know
the mother, and the son had
NOT KNOWN me —
 image of myself
 other than myself
 carried away by
 death

which takes refuge
 your future in me
 becoming my
 parity through life
I never will
 attain

He is epoch of
 one
 Existence where we
will meet again,
if NOT a place
 and if you
 doubt this
 the world will
 be my witness
provided I
 live long enough

father who
born in wicked
times had
 prepared for his son
 a sublime task:
To fulfill the Double
via his own
child — the pain the desire
 in sacrificing himself
 to what no longer is,
 will they
conquer strength (the man
 he never was)
and will he accomplish the
 mission of the child?

The ultimate aim
would only have been
pure flight
from life —
 you've done it
beforehand
 by enough
 suffering, sweet
 child — so that
That be counted
for your lost life, your own
people have bought the
 rest through suffering
their no longer having you

Pray to the dead
(not for them)

 knees, infant
 knees, need
 of holding him there—

his absence, knees
 buckling and—

what realer deaths
than a child's!

Hands coming together
toward him
 we no longer can clasp
 who is
 but a space
 separating

Beloved

 generous heart
 good son of
 a father's

heart
beats
 with very great plans
 all come
 to Nothing —
 as was necessary
to inherit this
wondrous filial in-
telligence — the

resurrecting of it—
constructing
with its flawless
lucidity this
work too
 vast for me,

and so (depriving
me of
life, sacrificing
it if only for

the work to be
him grown up—
deprived, and
doing it sans
fear of playing
with his death
since I'm
sacrificing my
life for him since
I accepted this death
 for my part
 (imprisonment)

Paragon
 we've KNOWN
through you this 'something
better than ourselves'
often eludes
us — yet will be
in us — our
acts — NOW

 child, idealized
 sperm

Father and mother
 vowing not
 to have an-
 other —
 The grave dug by him,
 life stopt there

Vain
 remedies
 left there
if nature
hadn't so desired

 I myself shall
 find for
 death

merely painkillers,
consolations for us,
 doubt — then
no doubt! its reality

child our
immortality
 in effect made
of buried human
hopes (the son)
entrusted to the woman
by man despairing
after youth
of finding the mystery
and taking woman

Sick
 after the day death
arrived – marked by
sickness :
already he no longer is but
what later
through death one would
like to see again –
bringing death and corruption
together – appearing
as such with his suffering
 his paleness

Sick – this baring of the heart
like the child

appearing to us:
 There's profit in those
hours when death
 strikes

He still
 lives – is
Still for us

 The poetic grandeur
 of illness

with gift of language
I could have made you
 my son child of the work
made of you king
 instead
 NO, sad of son
 inside us
made you unequal
 to

 the task

 remember no, this
 proves
 that he
 bad times did it,
 he played
 this role!
lips closed, etc.
 Natal
 etc. speech
 forgotten

It's me who
has helped you ever since —

brought back
the child to you —
 youth or suffering
learned from history?
 forgotten from which
 there's nothing

 I will not have
 suffered — being
 for my part
 only a student of that
 etc. (dead

then, you were
 only me
 since I am
here alone and sad—
 No, I re-
member another
childhood—
 your own :
 two voices
but without you
I wouldn't have KNOWN

before creating
 them —
so it's me —
these damned hands
that've left you —
 silence
 (he forgives)

O leave ... us
with this word
confusing both
of us
 uniting us
finally
 for whoever has
called it
 yours)

Cruel
etc.
 manifestations —
O let me — No,
you still want
ancient egypt,
embalmings,
daylights, crypt
techniques — All this
changing

once barbarous and
external
matter
Now
moral
inside us

wants
to outwit death

I hear a
woman's tears—
O I recognize
you are strong,
cunning
etc.

Brother sister
not ever absent

will not be less than
the present

Feeling the immense
 void, burst
 at night
 produced by what
 would be his life
(because he doesn't
 KN<u>OW</u> it) —
 that he's dead
 lightning flash?

 crisis —
 pain

the moment one has
to break with
living memory
in order to bury it —
place it on a bier —
hide it amid
the _brutalities_, the
rude contact of placing
it on the bier, etc.

in order only to see it as
 idealized
afterward — not him
existing there but
a germ of his being
taken back into himself,
a germ allowed
to think for him —
 see him and

the vision (the ideal
of this state), and
speak for him
 for in us the pure
him is purification
becoming our
honor, source
of our best
feelings, etc. plus

a true return
to the ideal

The treacherous blow
of death, of

evil his NOT
 KNOwing anything

is my turn
to deal, precisely
because the child
is unaware

Time of the
empty room

until it's
opened—
perhaps everything
follows from that
(morally)

He knows nothing!
and mother weeps
 (an idea there)
—yes, let's take
it all upon ourselves,
i.e., his life, etc.
for it's sinister
 NOT KNOWING
 and no longer being

With your little hands
you can draw me
into your tomb, you
have that right —
as for me
who are you, I
let myself go
 but if you
want, for both of us
 let's make

an alliance—
a proud maidenhead
and I will use
the life remaining
in me to...

—why not a mother
then?

ceremony—
 coffin
 etc.
 One saw there (the father)
all the concrete facts
that allow us to
say, if need be:
 OK, that's fine, it's all
there,
No harm then in thinking
of something else
 (the reformation

of the spirit that
holds eternity can
wait
 (so be it — but eternity
 across my own life

a father
shaping his spirit
(himself absent — god! —
as one might have
shaped it were he here
 even better —
 but

sometimes when all
seems to be going
so well, straight
to the ideal
 one cries out
in the tone of a mother who
herself has become attentive—
 It's NOT that at all:
 I want him, him

 NOT me

You look at me
I still can't tell
you the truth
— I don't dare, so small —
What's happened to you

one day
I will tell
 for man
I don't want

you not to know
your fate

and man
a dead child

No — NOT
mingling with the famous
dead, etc.
 as long as we
live, he
lives in us —

it's only after our
death will his be —
bells
of the dead sounding for
 him

little
 virgin
 fiancee life,
 who would have been
 a woman

let me tell you
this to make up
for what you miss
 but —

O let
us, the tombal
father
 (talking of
what the two
of us know :
 the
 mystery,

mist)
 navigate
 the river
 your life, which
 passes, flows—

Make us
 suffer
you, who don't
much
 doubt, all that
Tantamount to
your life mournful in
 broken
us

 while you
 soar, free

for what, on this day
Of dead men — for him,
him

Sacrifice
 of the child

that earth
(mother) the mission :
city men

End of Part (I)

O terror
 he's dead!

he is ... dead
 (absolutely,
 i.e., struck down—
the mother sees it that way

 so that he seems
 to return, ill
 in the future—
 or their race having arrived
 at now

Mother (I):
 One can't
 die with eyes
 like that, etc.
Father lets us understand
in his agony,
sobs
 'he's dead'
 and it's in the wave
of this cry
child (II) gets up

from the bed,
looks round, etc.

(in (III) perhaps
Nothing, affirmed
 by death
and
) is given simply
to understand, in
the space of 'he's
dead (of (I), (II)

the father looks round,
stops,
the child still being
there as if to
seize upon life again—
 Now an interruption,
mother having appeared, hopes,
cares the twofold path
 man woman
 Now in
profound union
one with the other

 out of which

you his sister
one day
 (the abyss opened
after his death
surviving us
up to our own
when we go down,
your mother and I)
one day you must

Join us all three
together in your thought,
your memory
 as in
 a solitary tomb—
 you who on
command would come
from that tomb NOT
made for you —

sunset
and wind
 now gone and
wind of nothing
that blows
(there, there's the Nul
? to be modern)

tears, coming

of lucidity death
sees itself
across

Death whispers low
 I am no body
I don't even know myself
(the dead don't know
they are dead,
Not even that they are
 dying

for children
at least —
 or
heroes, sudden
deaths

otherwise
my beauty is
of the last
moments made
and light the beautiful
face of what
would be

me sans me

for as soon as
 (one is,
I am
dead) I cease
being

composed thus of
forethoughts, in-
tuitions, ultimate

shudders, I
only am
 in the ideal
state

while for the
others, tears,
mourning, etc..

and it's my
shadow unaware
of me who
puts on mourning

the others

Notes

though a poem
always is based
on facts, should
only use
general facts,
it so happens
presented
here together —

they often agree with the
last moments of
my delightful child —

thus the father
 seeing that he
 must be dead—

the mother, ultimate
illusion, etc., —

death, the purification
image in us
purified through and before
 the image
tears as well!

simply remaining
don't touch
talk to oneself

should be :
Is he dead (i.e.,
struck dead)
No —
and is he coming back
(to the space of
having to die)
from the terrible future
waiting for him ?

or better, Is he
still ill —

a sickness one is
bound to, de-
siring it
continue in
order to hold him —
keep him longer

Now Death :

'Why keep on
describing him as
restless, sad,
deformed when
I am kneading him
for the beautiful
sacred day
when he no longer
will suffer (on the

deathbed, but
 is
silent, etc., instead
of the former (I)

'O if he ever
were to die
—mother

can't do it alone—
does it have to be father
and mother
 meeting
each other before
the sepulcre — sans him,
is that it ?

the dreamer sitting
(don't be) talking
 with him,

 Not feeling you
on my knees causes
them to sink
and me to
Kneel

 No longer before
the familiar child
etc. — then, with

 his (Navyblue) suit
 but before
 the young god
 a hero made sacred
 through death

perfect family
equilibrium

father son
mother daughter

a broken
three, a void
between us
 looking for...

 All the better
 he doesn't KNOW of it

 and we receive all
 the tears —
 Weep, mother
 etc. (transition
 from one
 state to another
 so there's no dead
 death — ridiculous
 enemy
 who can't impose
 on the child
 the idea that you
 exist!

Death is NOT prayer
 of mother
 playing
 dead
 she
 don't let
 the child.
 KNOW
— And the father benefits

No more life for

me,
I feel myself
there in the tomb
beside you

or : ORDINARY POEM

It's true
you've done it,
chosen the wound
well
etc.
but—

this vengeance
struggle of a genius and
death —

Dead
there are only con-
solations, pious thoughts-
but what's done is
done, you can't come
back to the absolute
contained in death—
and meanwhile
setting aside

life, joy in being
together etc., this
consolation has
for its part origin
and absolute basis
in what (for example,
if we want
a dead being to
live in us, in our
thought,
it's his being, his

thought, in effect
his best qualities
which arrive through our
love and the care
we take of ourselves
to live—
　　　To be, being
　　　only, with respect
　　　to thought, moral—
There, there is a be-
yond, magnificent

which recovers its
truth, all the more
pure and beautiful
than the absolute
death-rupture, be-
coming little by
little as illusory as
it is absolute (which
allows us to appear

to forget suffering,
etc.

as this ill-
usion of surviving in
us becomes the ab-
solute illusion (in
both cases unreality)
terrible
and true

father alone
mother alone

hiding the one
from the other
they find themselves
together

O earth you haven't
 a single plant
 (what's the use)
 for me who
 honors you

 — bouquets
 vain beauty

The friends
 mysterious finger-
 point
 appeared
 drove away
 the deceivers

from a dead
 vain
 source?
stay there,
let it be
and let life go on
 rivering
 alongside him —
looked after by strict nature,
 the little boy fallen into
 the valley

of purity
the Double
 identity

 the eyes
 two points of
 equal view

His eyes
looking at me, doubled —
are enough
—already taken through
the absence and
the abyss

harmonizing everything?

Man and
absence —
 the spirit
twin to what
it unites when it
dreams, muses on

 absence, alone
 afterdeath, once

The pious
burial of
The body, mysteriously
made (this
fiction attuned to)

the sacrifice
 on the tomb
because of love —
 the mother —
 it's necessary
 so that
he still exist! (transfusion)
mother alone wanting
 to see him, who is earth

And since it's _necessary_
What do you _say_ to that
Don't cut me short

Mother-fears:
 he's stopped
playing
 Today—

Father listens, sees
 mother-eyes,
 lets the other be
taken care of — muses on him

Mother-tears—
 a play
slowly quieting down
 in the Double
point of child-
 hood-doomed eyes—

the tomb a memory
of the old man
 (who speaks)

(I) cry of the mother
 flowers
 gathered for
 the grave – left there

(III) the tomb
 father

slow at sacrifice —
 earth changes him
during this period into

another mother
(is mother silent?)
—eternal and speechless grief

If he heard us
he'd be angry—
 Suppressing it
therefore,
 a sacrilege without
 a tomb
his knowing it!
 a shadow

No—for there's
 no death, divinely
 in us—

transfusion
a change of a way
of life, that's all

What's that!
 enjoying the
present
 and forgetting him
 absent—
 Simplistic!
There's no 'taking hold'
 of being by
 what has been absolute

Bitterness and
the need to avenge
when it
gets rough—

desire no longer to
do anything,
lacking the sublime
goal etc.

is What! the
 overwhelming the
 terrible death

 striking one
 so small

I say to death let go —

god, she's inside
 NOT outside us

He's dug
our grave
by dying

a privilege

Friend

friend
shrouded in the vision of
the child
you alone don't know —
you look at me
as at yourself always
astonished
Close those sweet eyes —
Don't see — I'm taking
charge
persevere
and you'll live

Seeing him _dead_
 — mother-fears
 at the deathbed
 (at the end of
 the play (I)
 end of (I)
 break-up,
 the voice crying up to
that point, for the silent child

and joining (the eyes
closed) the father
 (mother has closed them)
"NOT KNOWING
where he is" burying him in
 the shadow—
 struggling, struggling

O that the eyes of the dead
etc.,
 being more powerful
 than the most beautiful
 of the living

 might lure you

(split from (I)
 to (III:)
 the dead child there—

 speaking often to
 him:
 I pick you up, child

 bedroom blazing thought
 burial
 in
 (II) tears of the two
 hidden

 one in the other

Tomb – fatality –
 The father: 'He should
die' –
 Mother not wanting
 to speak to her
 offspring that way
 and father returns
to his destiny ful-
filled
 as a child

earth speaks
 — mother at-one with
earth
through the hollow grave
 — through the child — where
she will later
 be

Sister
child remains, who'll
lead a future
brother —
 exempt from
the tomb of
father mother and son
 via her marriage

Pain's not vain
tears falling
unaware but
emotion Nourish-
ing your shade
Coming alive in us

instating it

as living tribute
to him

Don't cry so loud
 —he'll hear

— The daughter, Thunderstruck

for what was he born NOT to
be for mother
 so beautiful
 so —

 terror in the father
 cursing his blood —
 the mother if
 made to exist, her eyes!
 what good being so anxious
 'he'll live'! (last cry)
 with cares, etc.
 at least death
 takes on the meaning

 he or mother
 May know it
 (sometimes he's
 turned away from me—

 such an awful sacrifice!
the father later
will connect
everything by
prolonging
his existence,
reabsorbing
 etc.

Silent father —
 genesis of thought

O the horrible secret
I'm possessor of
 (what to do with it

but become
 the shadow of his
 tomb —

NOT KNOWN —

 That must die

Aftershock
of eternity
Thanks to
our love
he prolongs us
beyond

(in exchange
we give
him life
by making us
a Thinker

(tenderly): You don't have
 to cry anymore —
No more crying
You're here
 a man
 I can tell you
what you don't KNOW —
 that you were betrayed —
 lies, etc.

old
 god of his race

 as poet
 he who NOT
 as man
 stirs up
 each of our movements
 etc.
 golden!

Afterward you won't
take it

yes
I recognize
your power O death

in the worst of it
you took it—
there's only more
of spirit in us, etc.—
powerless against human genius
but human death,
so much of humanity
of century of stones of tombs

(stop
the earth, that open
hole never-filled
 save with sky :
 indifferent earth
falls —
 No flowers
 bouquets, our
 Celebration and life

Tiny child
death was able to take
unaware —
　　but I don't
dare uphold that
gaze of the young
man already
incensed in him,
　　full of the future
good and <u>evil</u>

Of race in
me
this gaze
pursues beyond, into
absolute futurity
our reunion

is necessary?
according to what
ritual?
to bury him in the name
of race, ancestors, with

immortality
or my
new ritual?

The cemetery
necessity of going
there to renew
 the fear —
the pain through
 dear existence
the idea of there

When illusion
is too strong to have it
always within one —

No, you're not dead,
you won't be among the
dead but always with us

Mother – identity
with life that is death,
the father taking up
the rhythm held here
hanging between
the mother
suspended life
that is death

POETRY – thought

Not dead—you won't
deceive him—
 I profit from
the fact you exist
for the happy
 ignorance that is his,
but on the other hand
I take it up again
 for the ideal tomb

I want to suffer everything
 for you
 Who are unaware
 Nothing will be

taken away (as
you) from unheard-of mourning

 it's me, the man
 you would have been

 going from

Now for-
ward to be you :

 father and
mother by
 two —
 their love

idea of the child

 weep, mother —
 as for me I think

The Tomb

(I) here the sob
the unworthy protest
 is projected to infinity

(II) taking upon himself
all his sufferings
 in a way

(III) being able, then, eyes
raised to the sky
to draw the calm and
final line from the heavy
tomb

gravely –
a thing so painful
before,
but NOT without
(sacrifice of
pleasures?) Throwing
once more on this
sinister line
effacingly
the last flowers
once missed for him

Yes sir
 yes, you're
 dead
At least that's
what the announcement
says —
 and laughing inside
me — it's horrible
writing this as
yours,
 you who will very
well see, O

Love, if
I couldn't
hug you,
press you in
my arms
 it's that you were
in me

 Dear comrade of
 the hours
 I called bad, no
 later than those
 later I'll speak of

myself
perhaps as
the ambiguity?
If only that
were possible!

Pain and sweet
 pleasures
 from the sick
 apparition —

Mother:
 He won't live!

(the two :)
 father in front of
 the tomb

 (push mother aside?
 then return?)

The sacrificing father
 getting ready—
but the idea remains and
 everything
thereupon is lifted from him

and offered to the absolute

Bitter –
 so much the better
he isn't a man,
 but his eyes...
 his mouth
 –Who's speaking this, his
 lover perhaps

 O lover, girl I would
 have loved

to return to mother?

seen, returned dead from the
illness – eyes wanting
to pour out the day,
 giving the appearance
of play-acting, indifferently

 – he knows without knowing,
 we weep for him without
pointing it out to him –
 then enough tears: they

introduce death

One feels (the fatal blow
lighting up the soul),
that death
 and (thunder) everything
is collapsing—

 dream of leaving him a name
 etc.

already so changed
there's no more him
and the idea (of him) yes !
it's detaching itself little
by little

later, from the moment
death starts hovering,

To be sick
 will be considered
 as dead —
one already loves an object
 "reminiscent of him"
 — putting it right,

and sometimes hope
 cracks this furtive
 death —
 'No, he'll live!'

—life taking refuge in us
where our own terror –
 grave-horror
 attaches itself
in making the sacrifice

or poems to be,
for later, after
we are, dead

So that never
will future eyes
 full of earth
veil them—
 selves with time—

I can't believe in
anything that's
happened :
 The
 rebeginning in
 the spirit beyond—
 The burial
 etc.

death!
O you believe
you will take him
from me just like that—
from mother
 father

I confess
you can do
 a lot

What do you want, sweet
adored vision who
comes to me often
leaning over as if
to hear the secret of
my tears,
knowing you are
dead,
 what you don't know?
 No, I'll

Not tell
you for then
you would vanish,
and I remain weeping
alone, you and me
mingling, you weeping
for yourself
 a child
in me,
 the future
man you will not
be, remaining
sans life or joy

Vision
endlessly purified
by my tears

The child
　　himself so
　　　　beautifully
　　dead and the wild
terror of death
falling upon him
(deranged by the
mother's cry) through
the man he would have
become (seen in this
　　　　ultimate moment)

in order to rend the deathbed

O provided
he NOT KNOW
anything, have
No doubt

during illness—
but of what treason
is death
 unaware?

No, I can't
throw earth out
of oblivion —

> earth mother
> take him again
> into your shadow

> at the same
> time his spirit into me

Mother who has bled and wept —
Father who sacrifices, deifies

NoT me
 in me

and absence
is the always

self, the Nothing
 we
but self love
torturing the delicate
 soul—

Imply perhaps
 the cere-
 mony —
 funeral rites
etc. – in short, what
the world has seen
 (mass burial)

 to bring all back

to intimacy :
the void, absence
of the bedroom opening
the moment his
absence ends,
in order for him
to exist in us

 would be this
 3rd part

after he's been
taken away (end of (I))—
 out of the room,

 Then seeing how
 in (II) 'The
 sickness and
 the little phantom'
 would be framed—
 (III): going over

 what was before, towar
 the end of (II) —

 dead

Thus the furnishings
of immortality

and at the bottom of nature
he-me no longer
will play – mingling
with the countryside
 where he lies?

more particulars?

 Adorable heart
 O my image
 down there with such
 great destinies—
 what child
 ever like you
 I still
 dream
 all alone
 in the future

you know very well
if I agree
to live — to appear
to forget you
it's in order
to nourish sorrow
and this
apparent
 Oblivion gushing
more vividly

at any moment
in the midst
of this life
when you appear
to me from there—

Time — that body
takes to obliterate
itself in earth (con-
fusing itself little
by little with neuter
earth's vast horizons)
 — is when it
 releases the pure
 spirit

one was – which was
joined to, organized by,
it – which can take
refuge in us purely,
reign
in us
survivors,
or

in the absolute purity
time pivots
upon, repairing
itself

 as God longago did,
 the holiest state —

I who know it
through him carry a
 terrible
 secret!
 a father
 himself too much
 a child for
 such things —

I know it and it's
in that his existence
is perpetuated

I feel it in me
wanting if not
the lost life
at least its equi-
valent

death
where one's skinned
of body
in those left behind

and then (III)
: speaking to him,
isn't that it?

Friend,
you win —
 isn't it that
freed of all
life's
burdens —
 i.e., the old
pain of living

(O! I feel

you so
very powerfully—
you always feel good
with us —father, mother
but
free now, eternal
child everywhere
at the same time

and underlying all
I can

say for
I keep all
my sorrows for us —
　　the sorrow of
not-being, which
you're unaware of,
　　which
I impose upon myself
　(cloistered from
　the others, outside

life , where you
lead me
 (having opened
for us a
world of death —

The moral
burial
 —father mother
Oh
 don't keep
hiding it
etc.—
 a friendly earth waits
for the pious act of
 veiling it —
 allows

the other mother
common to
all men
 (where the last bed
goes, where he is
now) –
 To take it –
 let men be
 present, O

the men
there (under
takers or
friends ?)
 carrying him
off, followed by tears,
 etc.
 toward earth
 mother of all

Mother of all – her
own now
 and
(since she's already
a part of you, your
grave dug by
him?)
 becoming
 the face
 of a small man,
 a solemn man

Confederates
 of death
it is
 drooping
 sickness—
 myself—
 thinking
 mother?
 knowing

to close the eyes —
can't close
the eyes
will look
at me forever,

or, death aside,
the eyes closed, etc.,
I see him again, ill,
struggling against that
troubling condition

Little body
setting aside
a hand
at deathpoint

which a moment
ago was his

and the cry almost
without calling
attention to this body
set aside —
O son
as if a spiritualist
instinct in suspense
in a sky

burst
 apart

O this sacrifice
denying
his life—
 burying him
 Let's go on
speaking of him, extinguished

—in reality, silence

broken into two
I write to him
 (under-ground)
 decomposition
 mother sees
 what she shouldn't
 KNOW —
 then sickness returns
 up to the point all
 are purified! (by evil)and
 lie down —
 so beautifully dead
 the future tomb

(one makes it vanish
so that he remain within

us —his gaze
 (consciousness)
so long
regarded during
the illness,

 a triumph
afterward

 ┌— 3ʳᵈ part —
 break between (I) and (II)
 and between (II) and (III) ┐
 ⌐

— everything connected up

Not knowing his
happiness
 when he is
there... found to be
so naturally

 joined
 to the consciousness
 of death—

Real mourning in
the apartment
(not the cemetery)

furnishings

finding absence
~~itself~~
 in the prescence
of small garments
 etc. —
 mother

Little sailor,
sailor outfit.
 What for!
for the big
 journey
a wave carried you
 ascetic

 sea

fiction of absence
 cared for by mother—
 the apartment

('I don't know
what they've
done with it—in
all the trouble
and tears since—
I only know

(but she followed him at the cemetery)

he isn't
here

so he's there —absent—
and mother herself
becomes a phantom
spiritualized by
the habit of living
with a vision

While he the
father who
Constructed the
walled-up
 tomb
 knows—
 and doesn't
his spirit go there
searching traces of

destruction and trans-
 mutations
 into pure
 spirit ?

SO That
purity spring
from corruption!

No — I won't
abandon
 the Nul

 father — I
feel the Nul
 invading me

and if at the least
I haven't given
spirit blood
enough

for my thought
to make for him
a life more beautiful
 more pure

and like his fear of me — who thinks
 — alongside him

What I say
is true, it's NOT
only music
etc.!

bouquets

one feels obliged
to fling to the earth
opening to
the child,
the most wonderful bouquers
the most beautiful
producers of
votive earth,
 to veil

(or making him
 pay up

for the struggle
 of the two
 father and son—

 one to
preserve the son in
ideal thought,
the other to
live, rise again
etc.—

 interruptions,
 insolvency)

This is the way
 mother takes good
care of him —
 mother cares
 interrupting thought
 — the child
 between the father, who
 thinks him dead, and the mother
 life

 'look after him
 etc.

 — there —

It's only in (III)
The splinter of what
(break) was caused
by the cry of (I)
 is healed
little by little
everything is finished

child

a destiny
earth spells out
consolingly

And it's up to me
 the grave
 father
having created this being
 Not to let it get
 lost
 — through troubles
and the mother I don't want
 him to stop
 (the idea there!)

Appeared!
 shadow of
 my mother,
 mother and child
 until
 the poor day,
 the one I don't
 foresee —

if this isn't
 punishment — of
the children of other
 classes

 when
 furious
against
 a vile society
 which perhaps
 ought to
 crush him

through the cure of an
evil
I win back my
self by that
p/haps

193

About the Authors

French Symbolist poet Stéphane Mallarmé (1842-1898) was influenced by his contemporaries, Charles Baudelaire and Paul Verlaine, and was recognized as one of the most eminent poets of his time. His poem, "L'Après-midi d'un faune" ("The Afternoon of a Faun"), inspired Claude Debussy to compose his well-loved prelude which then in turn, with Mallarmé's poem, inspired Nijinsky's ballet of the same name.

Jack Hirschman (b. 1933) is an American poet and social activist who has written and translated more than 100 volumes of poetry and essays. He has translated poetry from many languages and has had his own work translated by others. He was San Francisco Poet Laureate, and still lives in San Francisco.